ANN ARBOR

Hand-Altered Polaroid Photographs

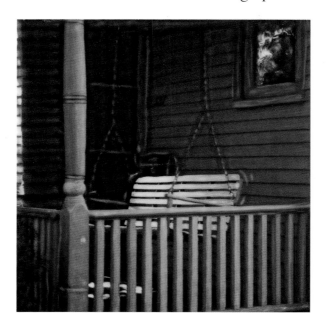

CYNTHIA DAVIS

THE UNIVERSITY OF MICHIGAN PRESS ANN ARBOR

Copyright © by the University of Michigan 2004
Photographs copyright © Cynthia Davis 2004
All rights reserved
Published in the United States of America by
The University of Michigan Press
Manufactured in Singapore
∞ Printed on acid-free paper

2007 2006 2005 2004 4 3 2 1

No part of this publication may be reproduced, stored in a
retrieval system, or transmitted in any form or by any means,
electronic, mechanical, or otherwise, without the written
permission of the publisher.

A CIP catalog record for this book is available from the British Library.

U.S. CIP data applied for.

ISBN 0-472-11404-2

To my husband,

JOHN BERRY

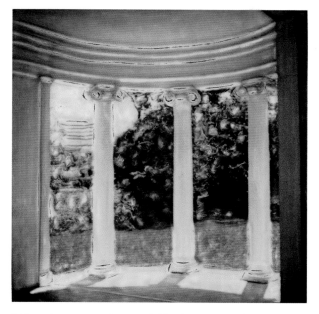

It would have been so much more difficult to accomplish this work without his loving encouragement and assistance. He was my chauffeur as we drove around Ann Arbor on his Harley seeking out subjects to photograph. He cooked meals, generally sustained me, and kept me going.

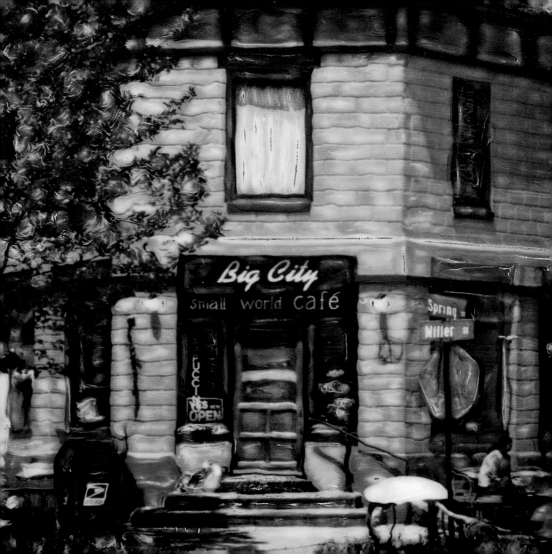

PREFACE

My interest in art began early in life. My interest in photography as an art form began at the University of Colorado while pursuing a B.F.A. degree in painting. After graduation, I apprenticed in the Denver Art Museum's Photography Department, which gave me extensive darkroom experience.

Photography is a diverse technical art medium, and I am continually drawn to explore the alternative processes that reveal the human hand at work. For me exposing the image onto photographic film is simply the beginning of the creative process.

By accident I discovered that the Polaroid Time-Zero film could be physically manipulated. I immediately saw the semblance to painting and was entranced that I could physically interact with the photographic emulsion. With some research and many boxes of film, I found that I could blend colors, create textures, and etch lines. I learned to "paint" with the Time-Zero film emulsion, and it became the perfect medium for me. I have now been working exclusively with the process for almost 20 years.

It is fascinating to me that photography's intrinsic nature perpetuates the perception of realism in the eye and mind yet is an illusion that can often reveal more than reality. These hand-altered Polaroid photographs have a captivating ambiguity and duality between photography and painting, realism and impressionism.

All of the images contained in this book were photographed and altered by me over a period of a year, although most were done during the spring and summer months. While it is difficult to capture the core identity of a city in just a few images, I hope that you will find in the book the essence and spirit of Ann Arbor.

Cynthia Davis

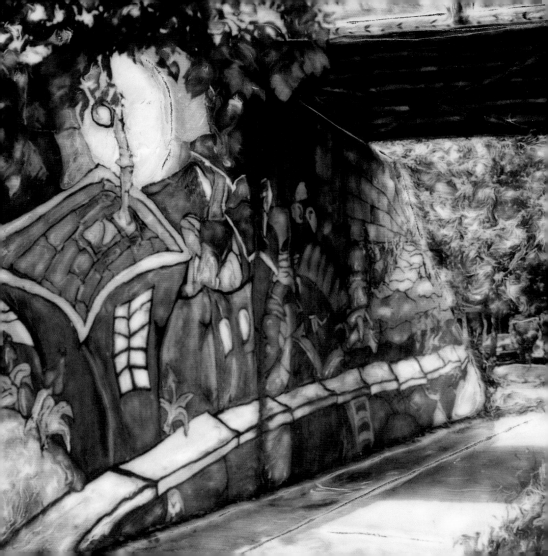

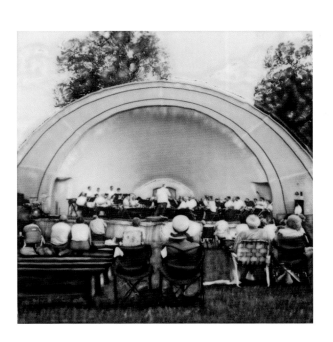

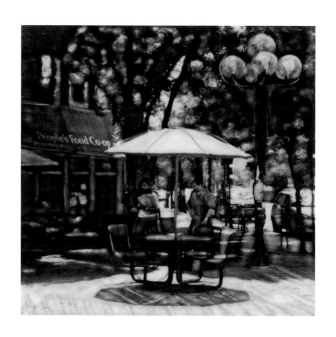

2

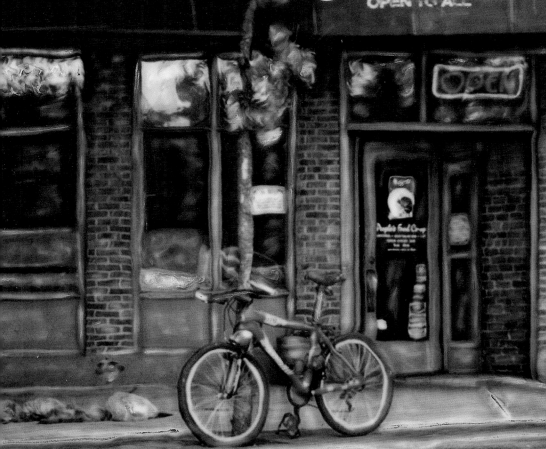

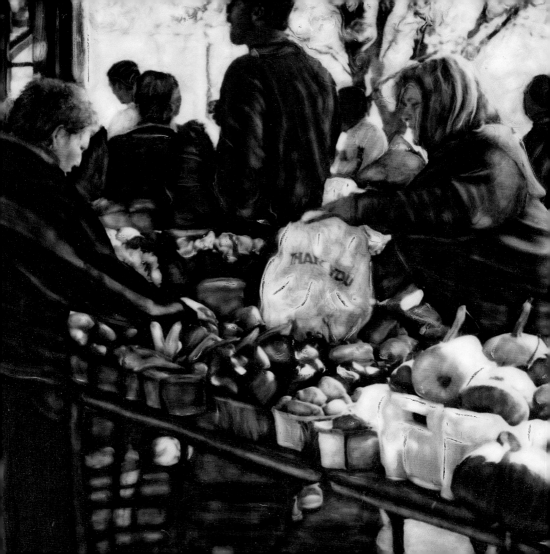

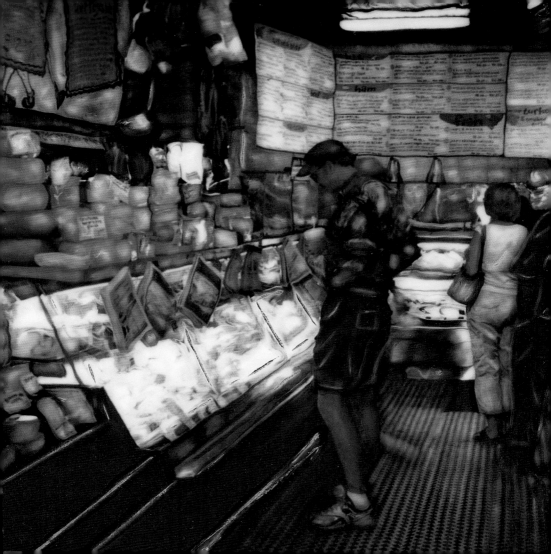

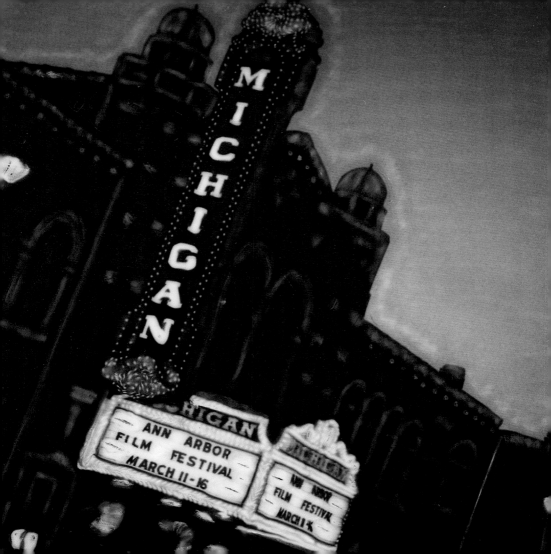

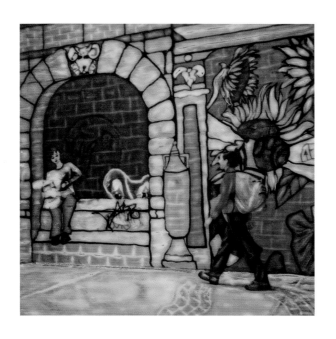

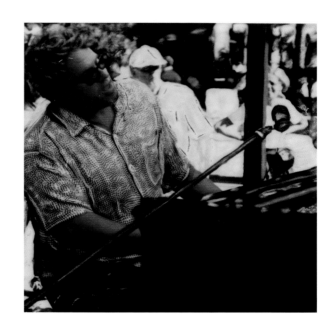

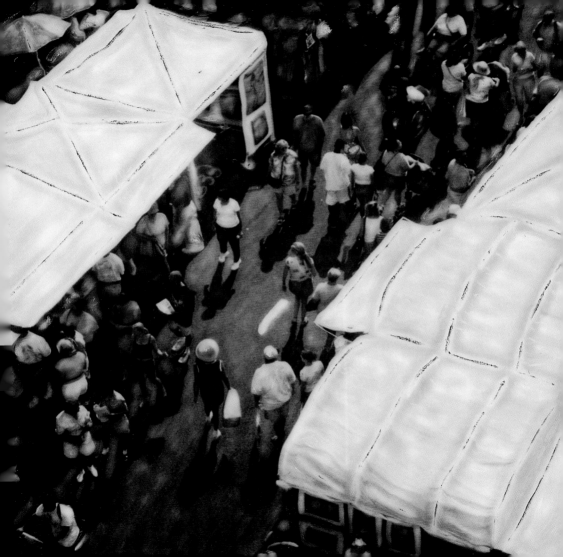

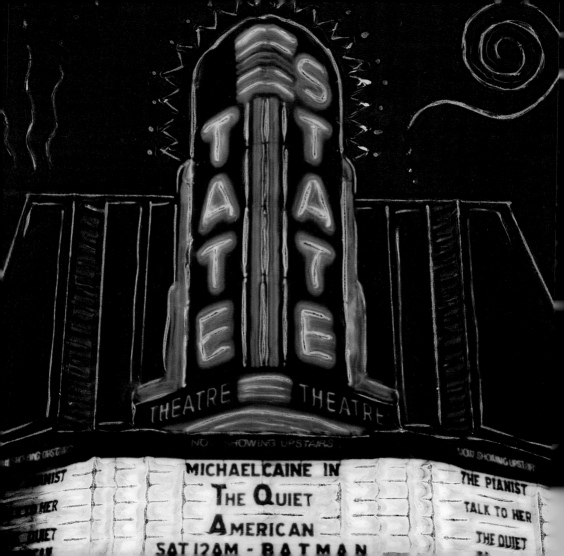

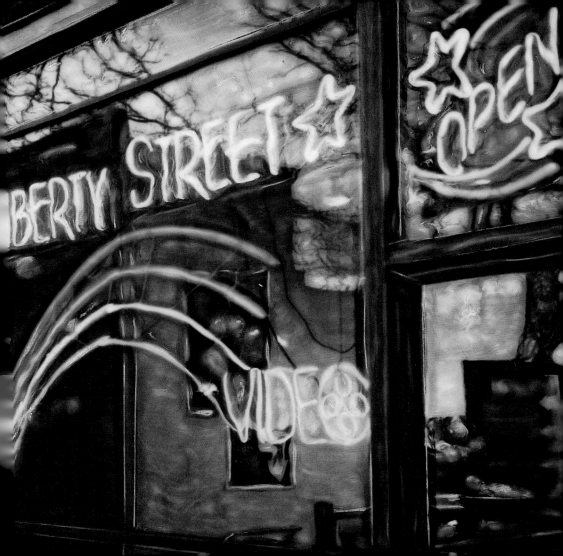

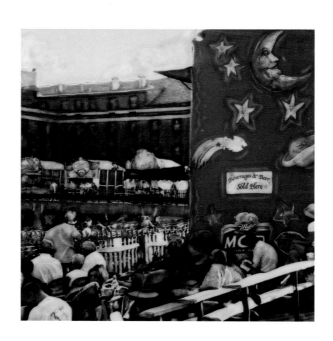

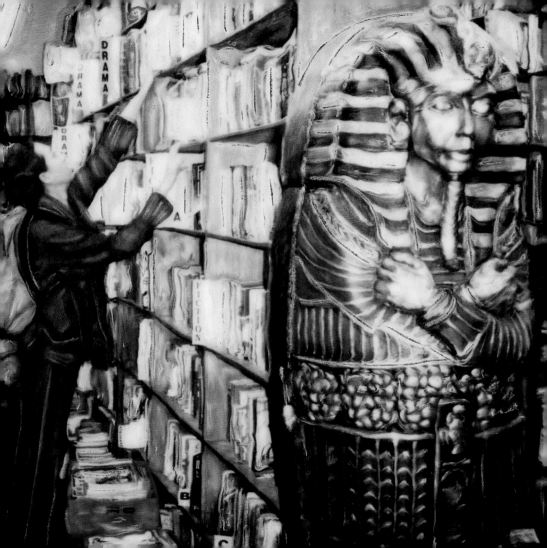

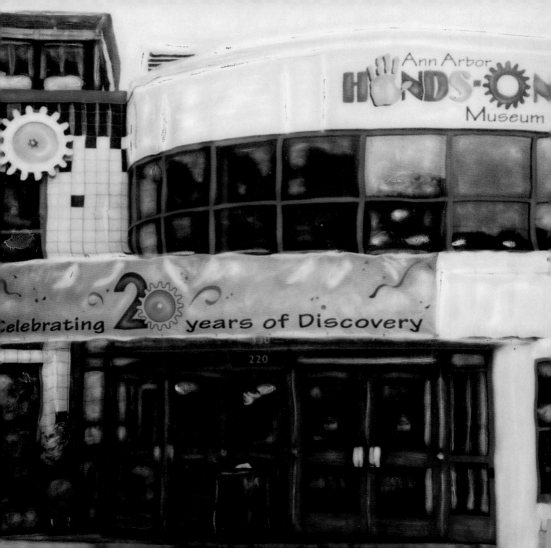

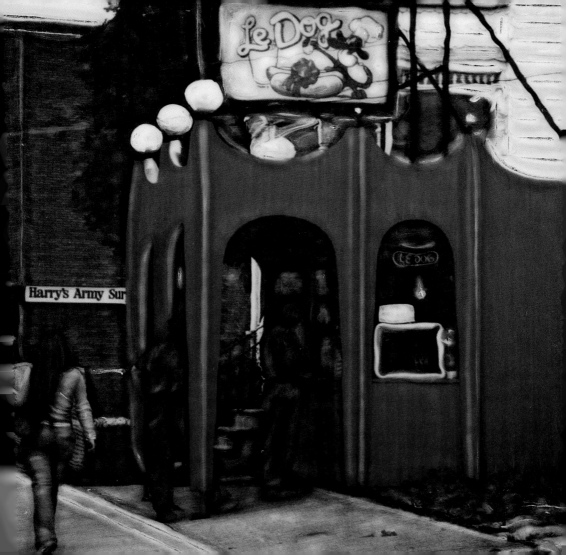

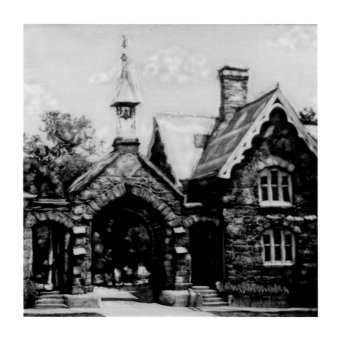

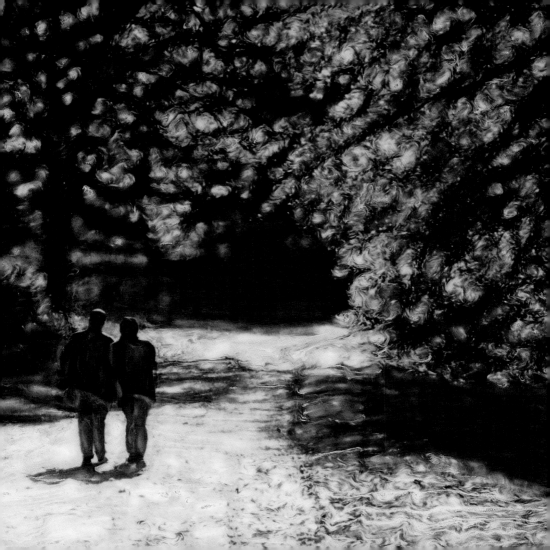

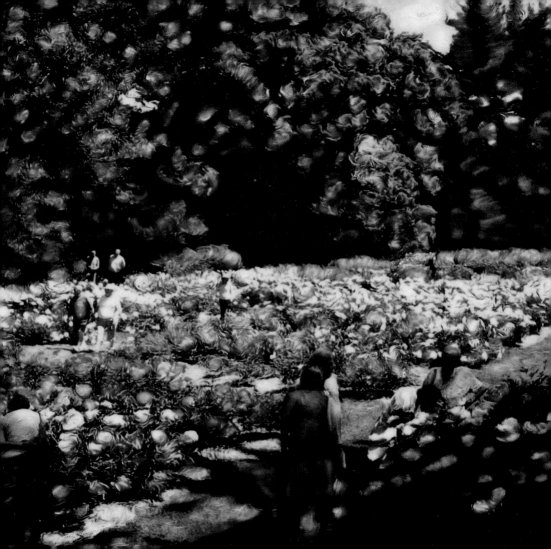

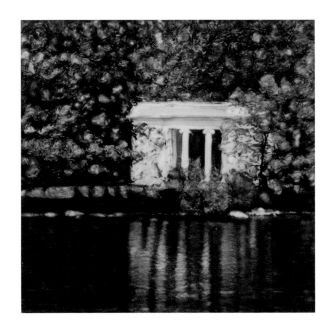

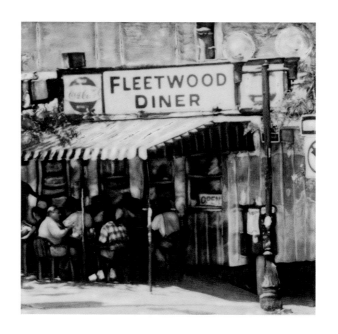

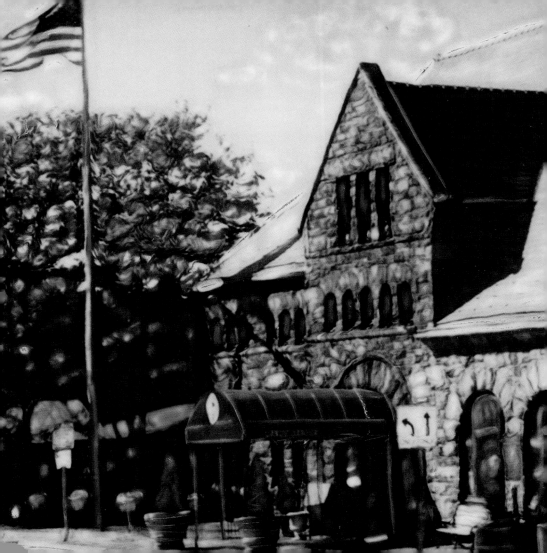

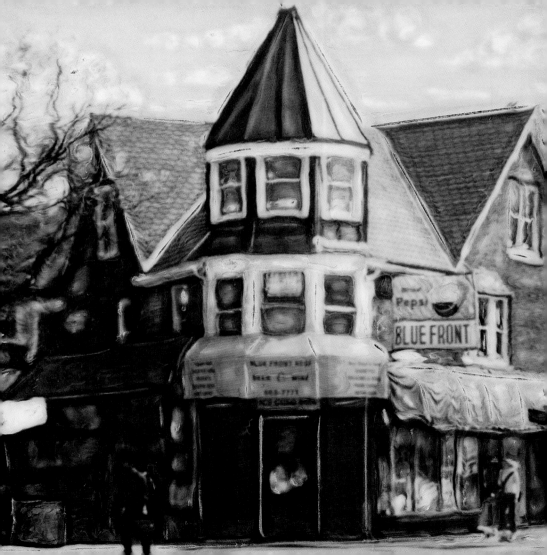

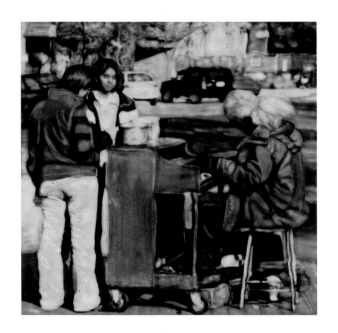

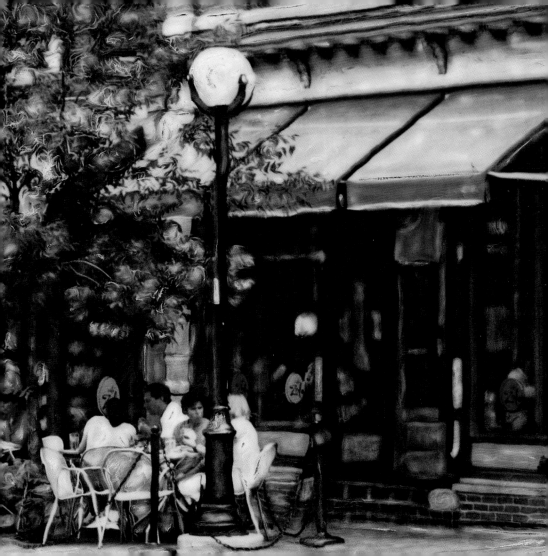

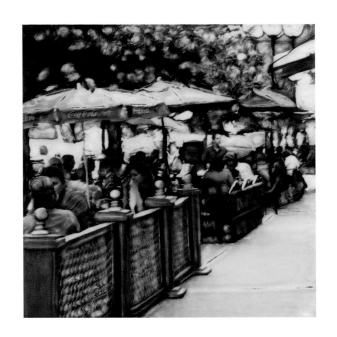

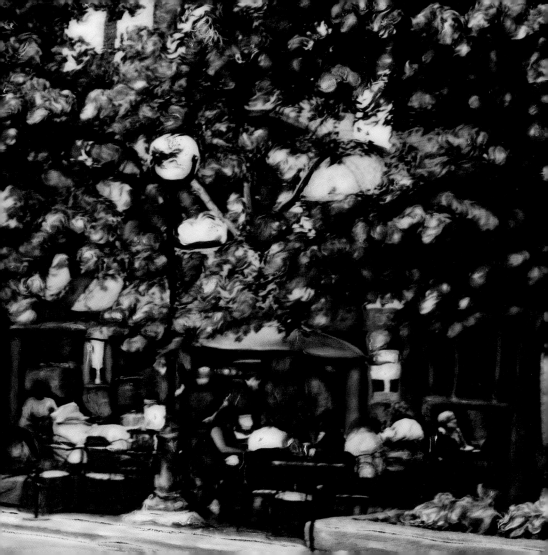

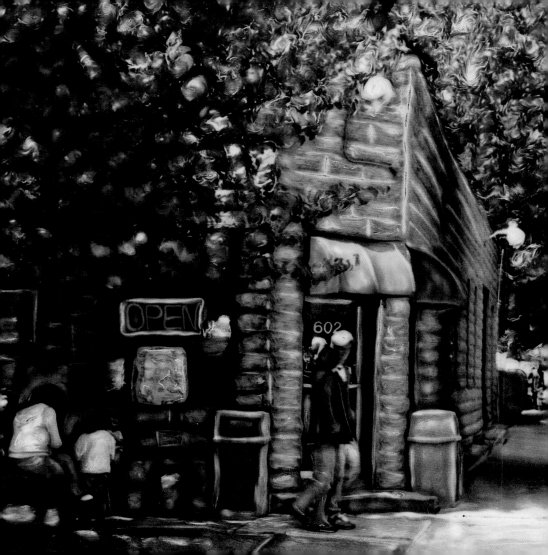

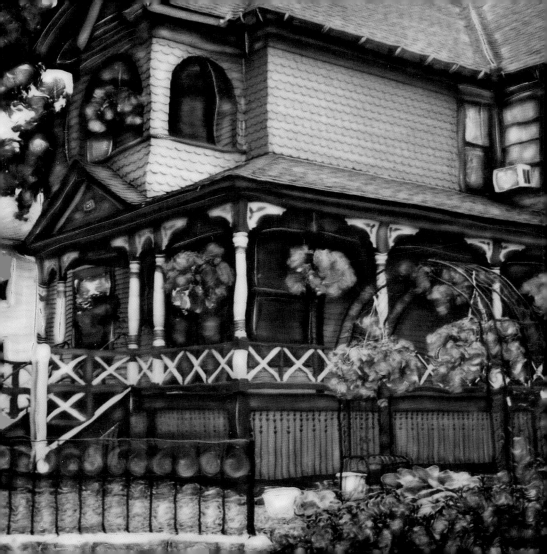

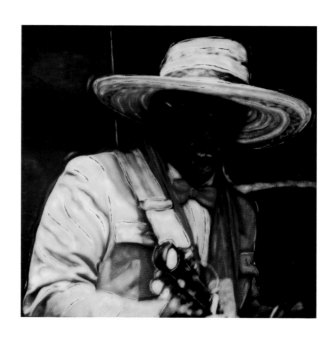

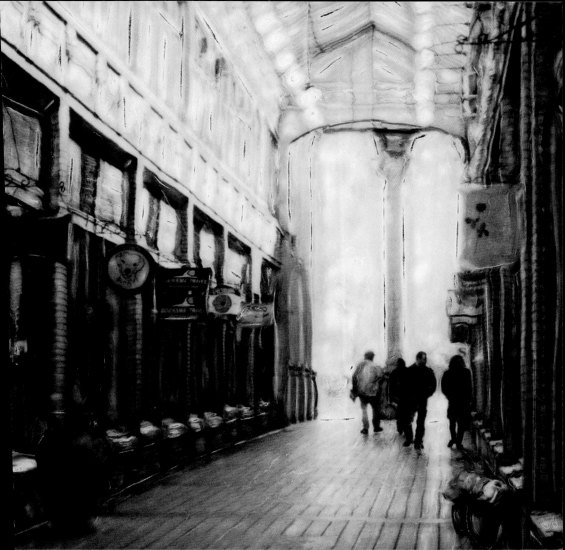

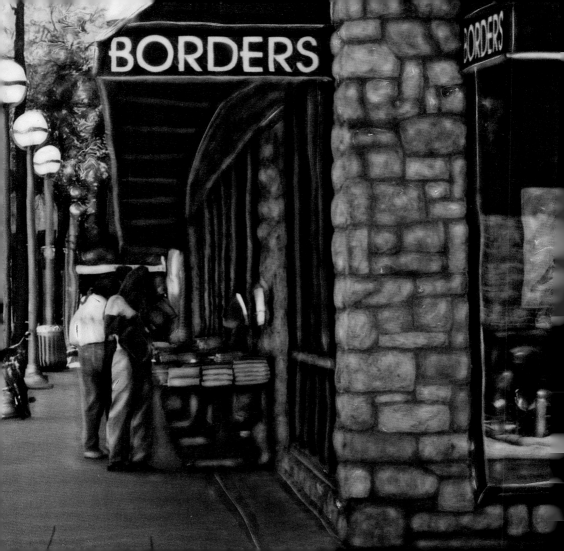

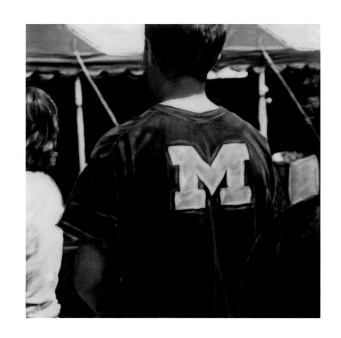

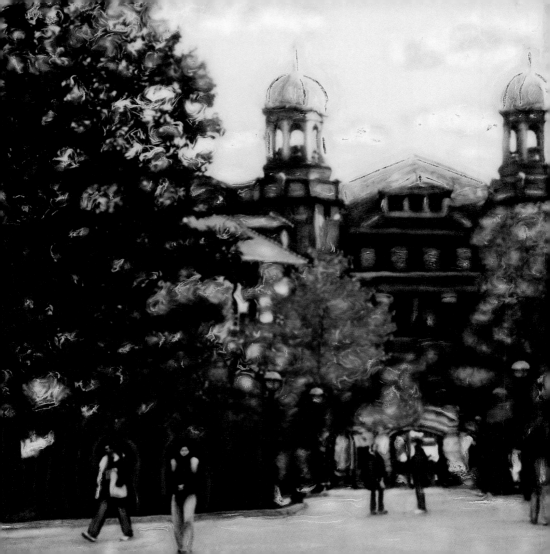

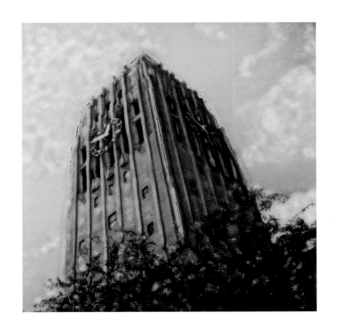

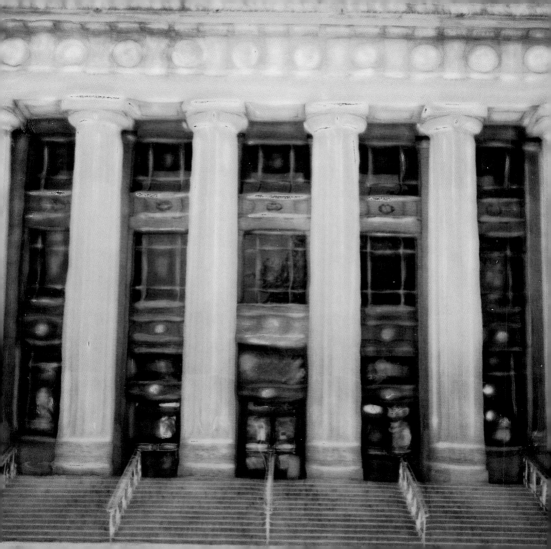

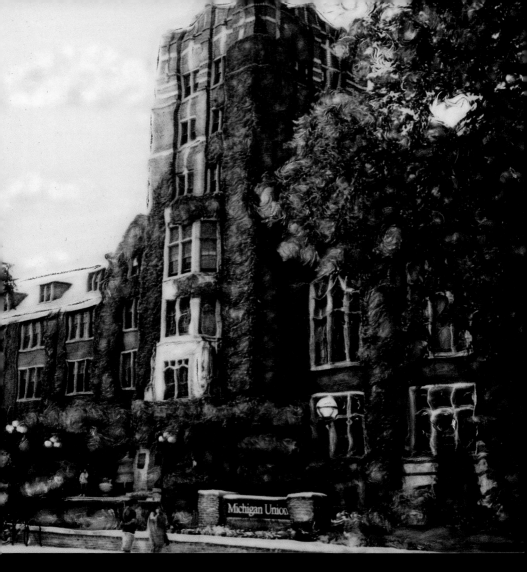

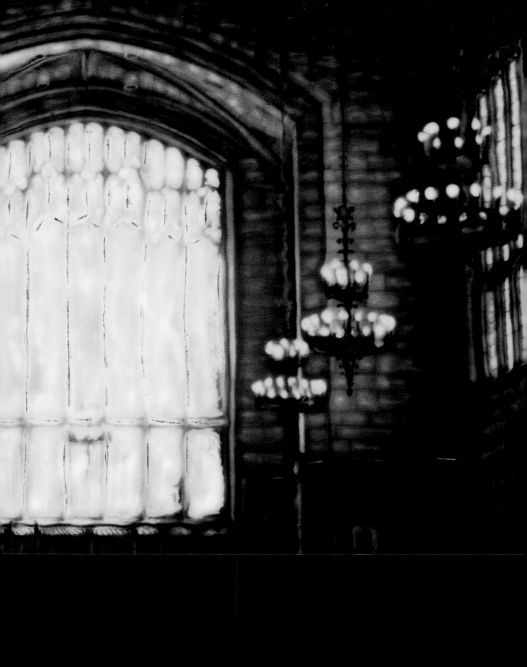

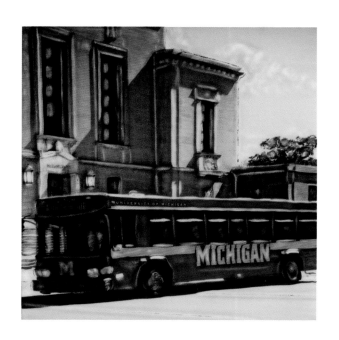

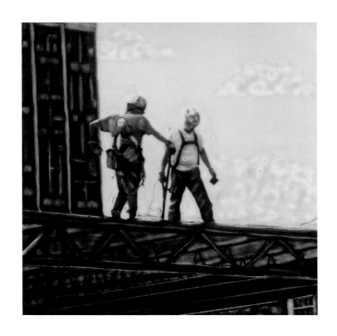

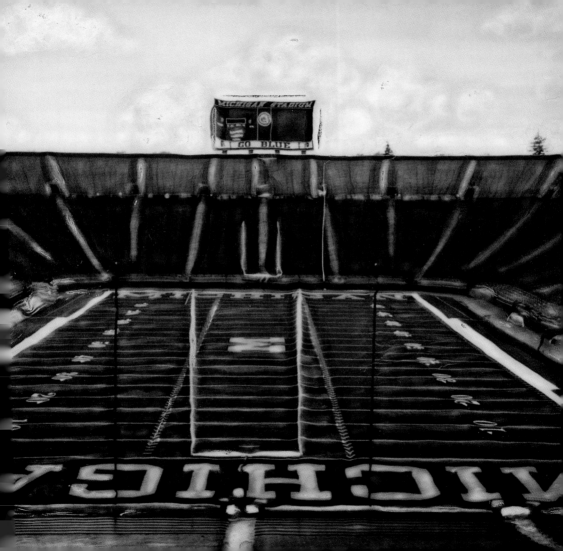

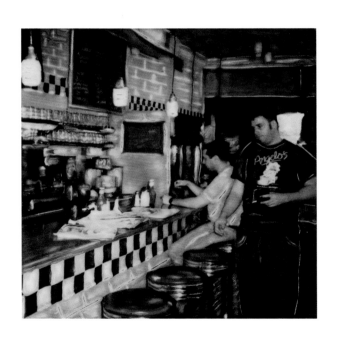

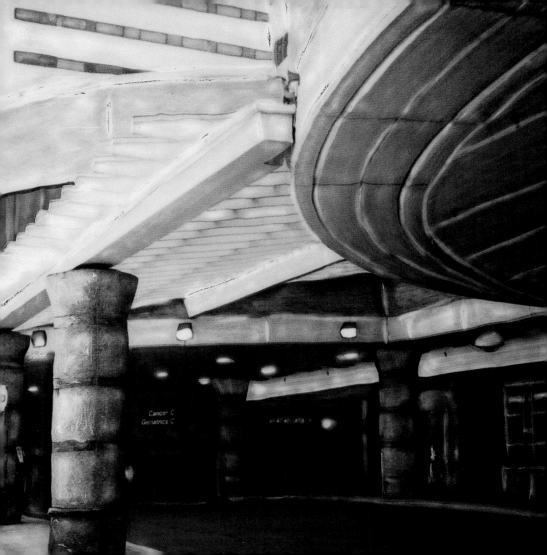

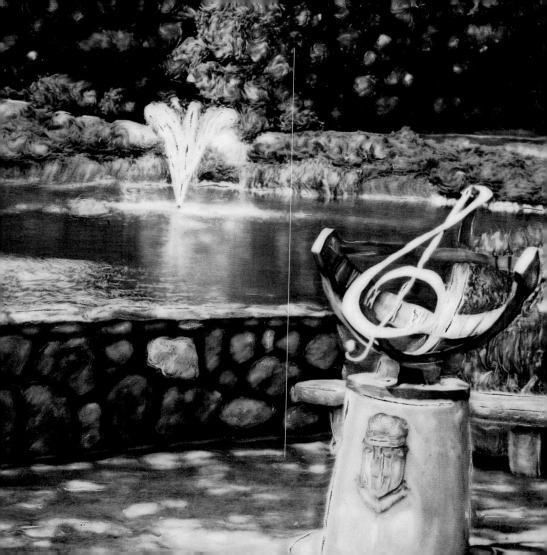

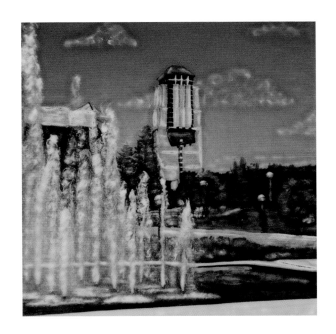

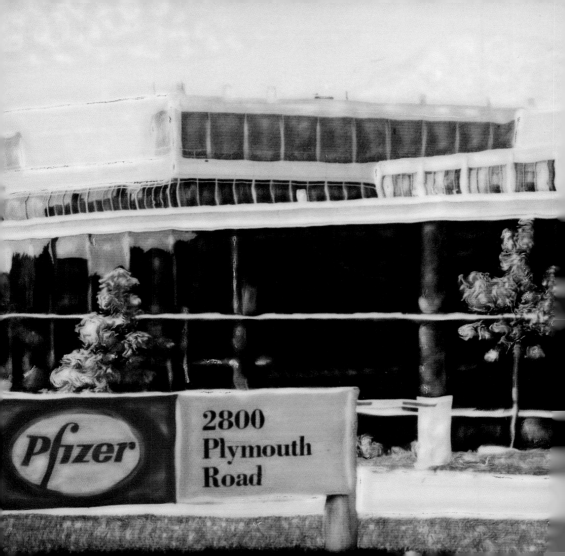

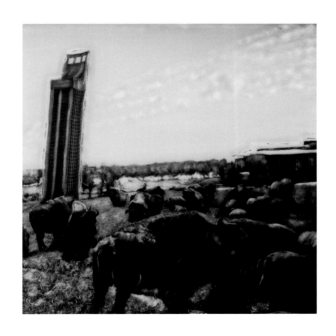